Rainer Strzolka

Grey

The City of Husum Diary

Hannover

Berlin

Galerie für Kulturkommunikation

2019

For years Husum has been one of the most attractive cities in northern Germany for me in its cheerful sadness. Every time I drive to my island residence, I stop there, visit one of my best friends and take a little photograph. All images shown here are unpublished and made with Leica R7 on Kodak Tri-X film material.

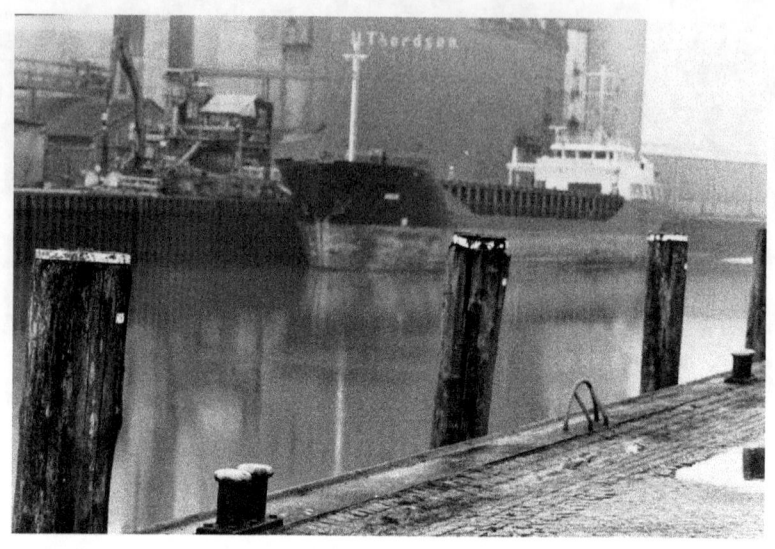

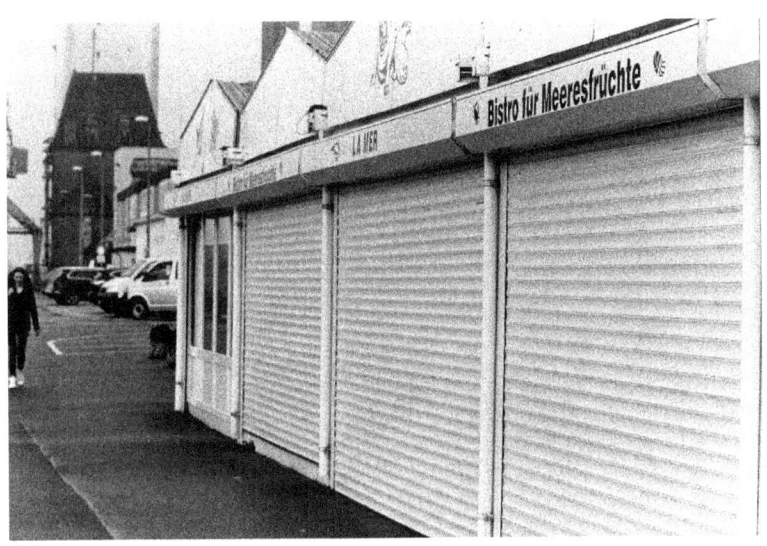

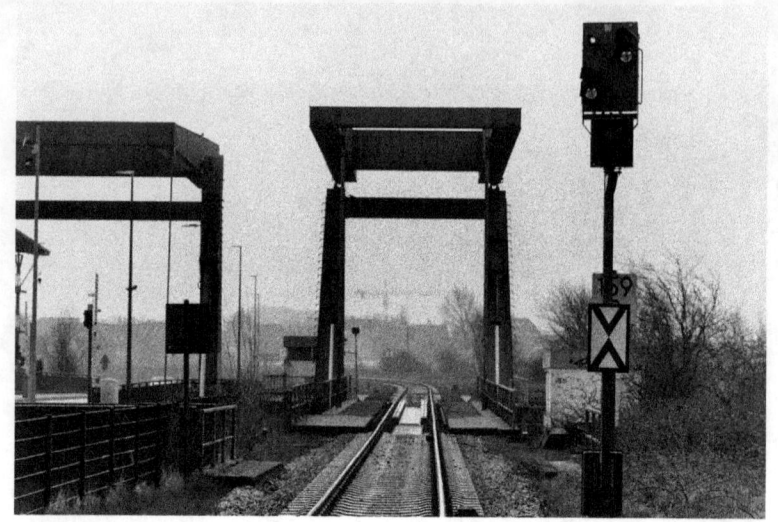

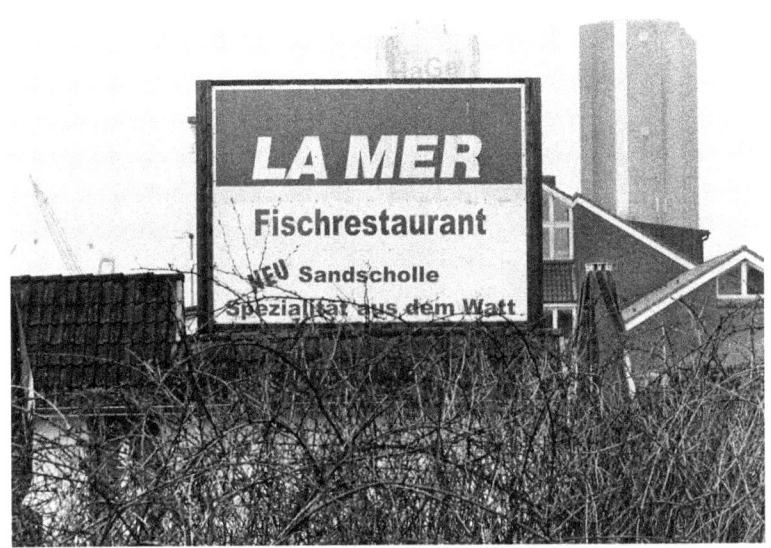

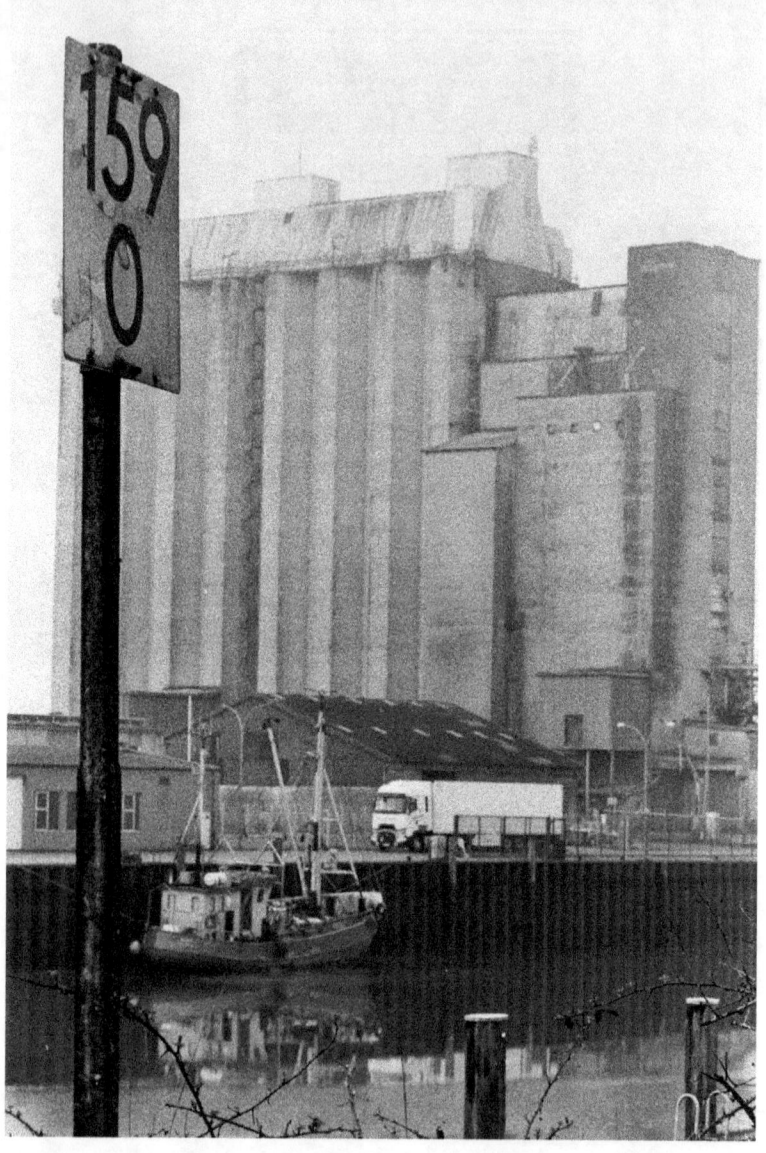

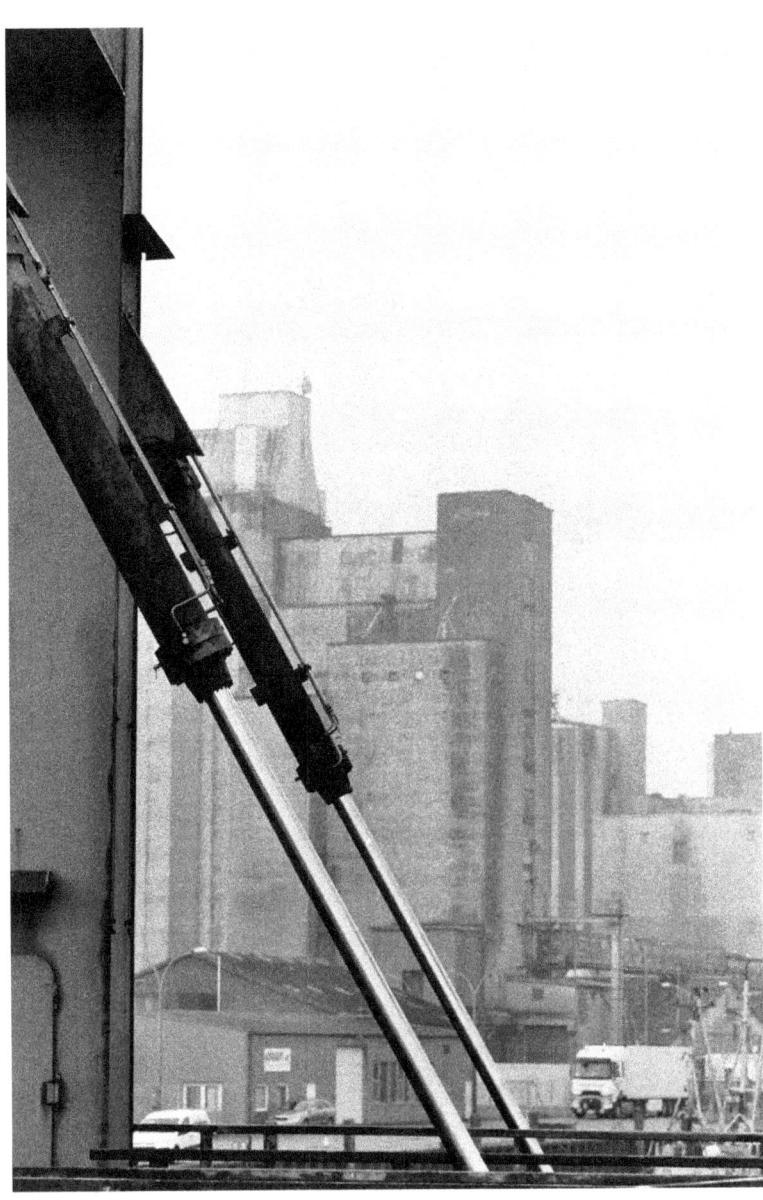

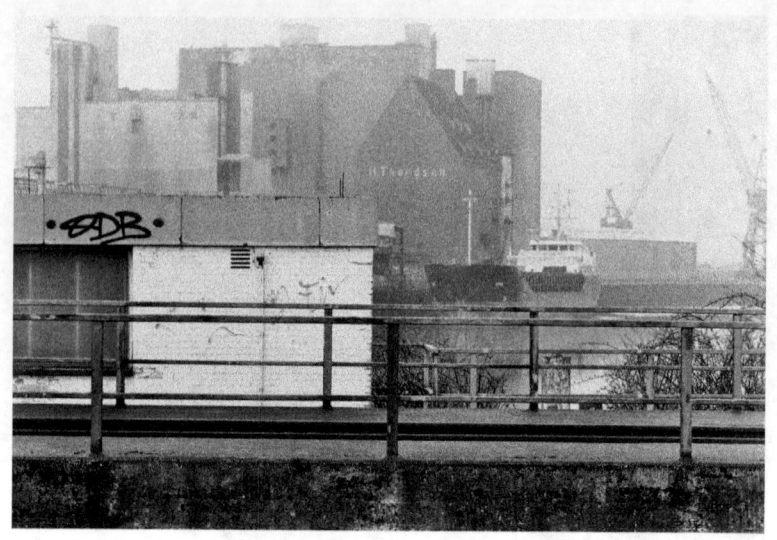

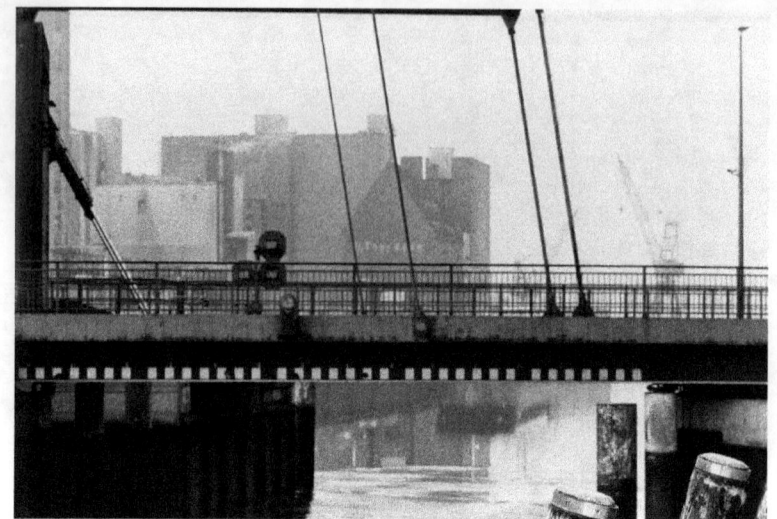

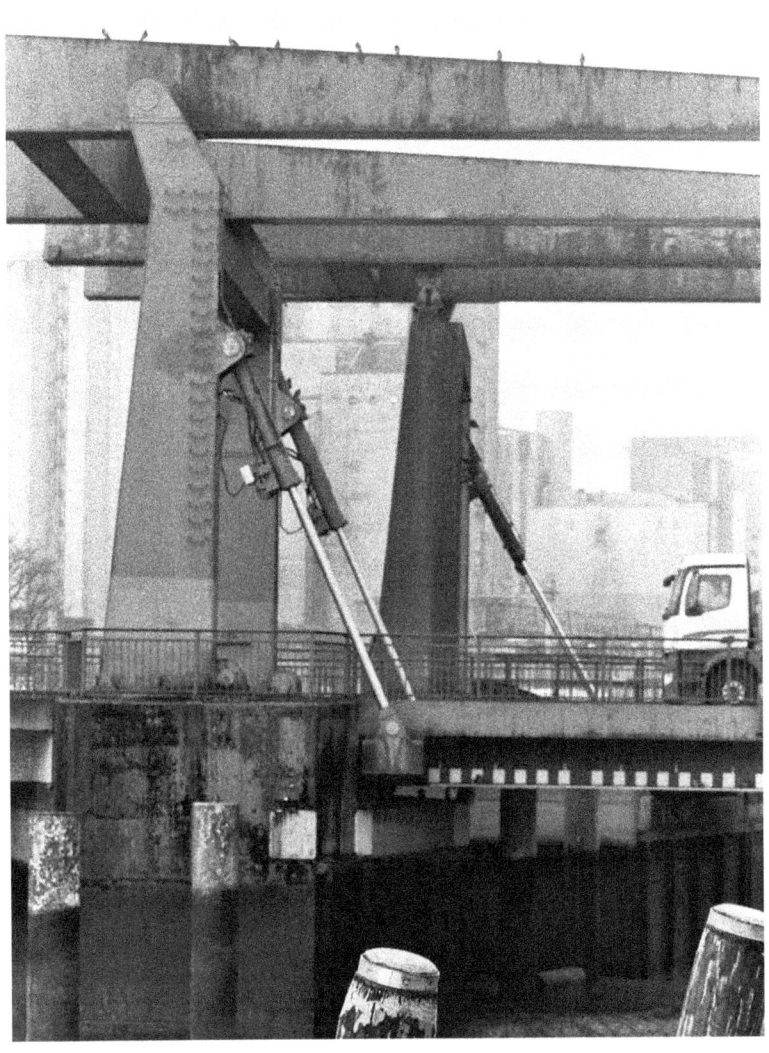

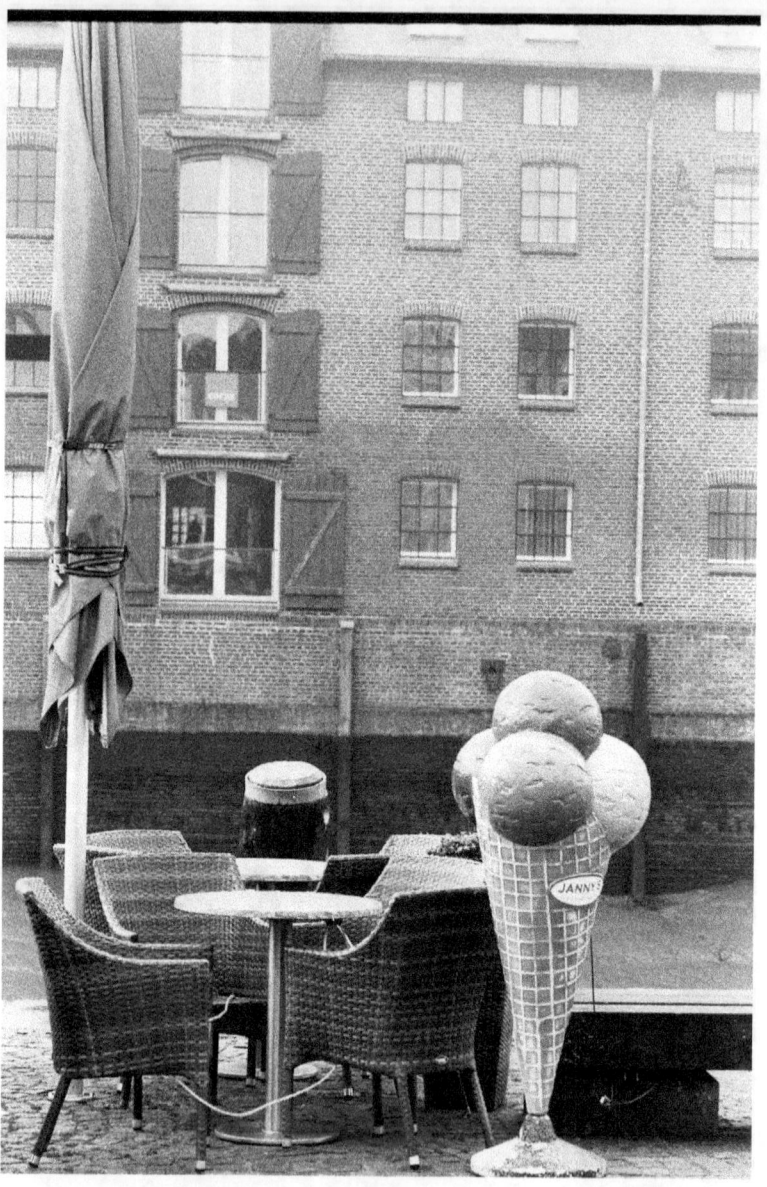

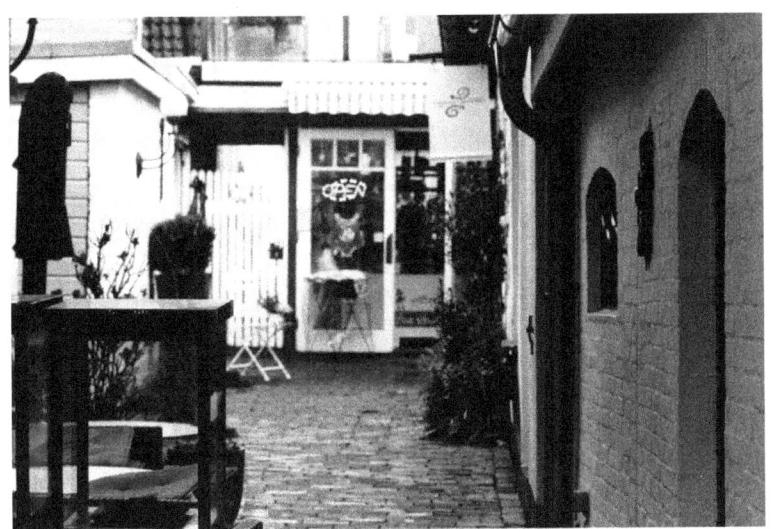

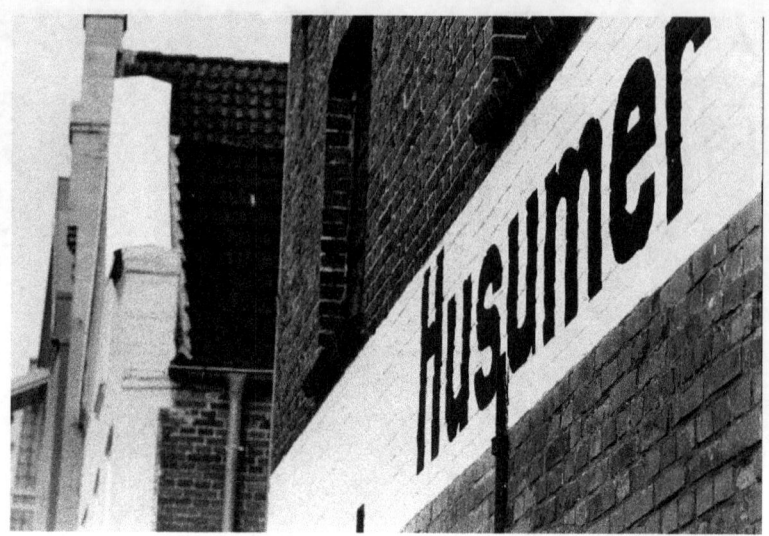

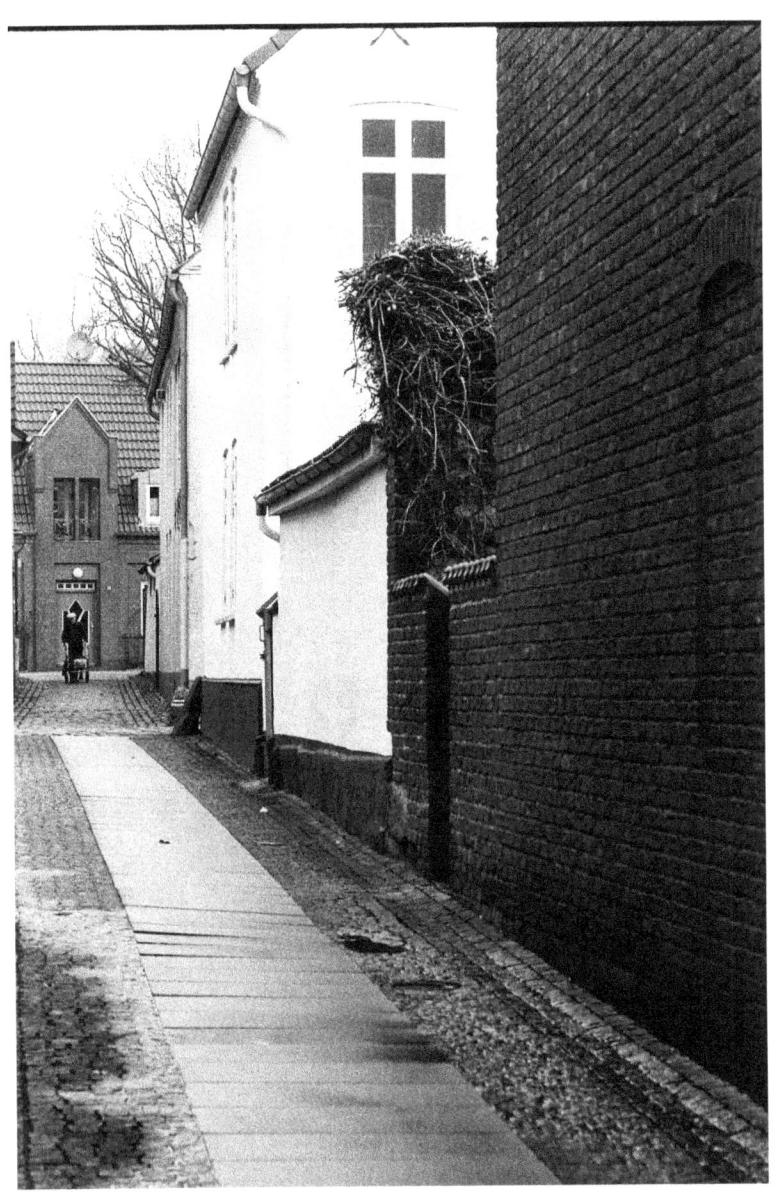

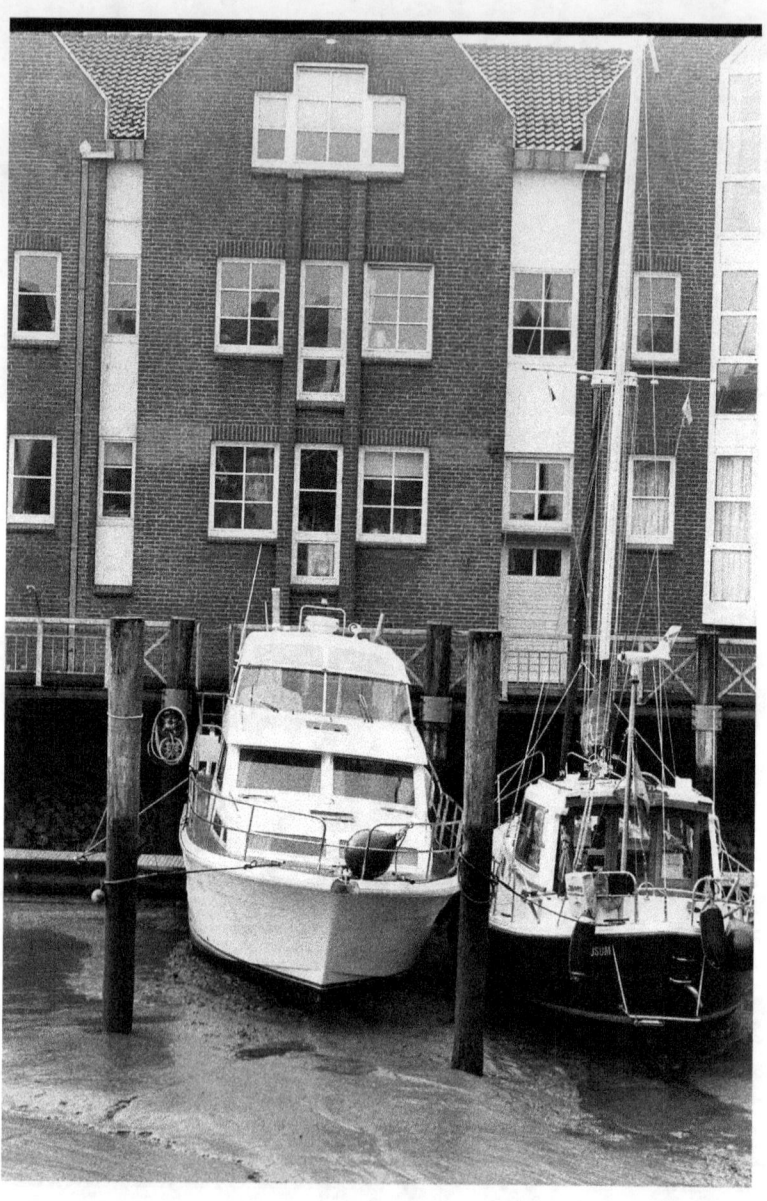

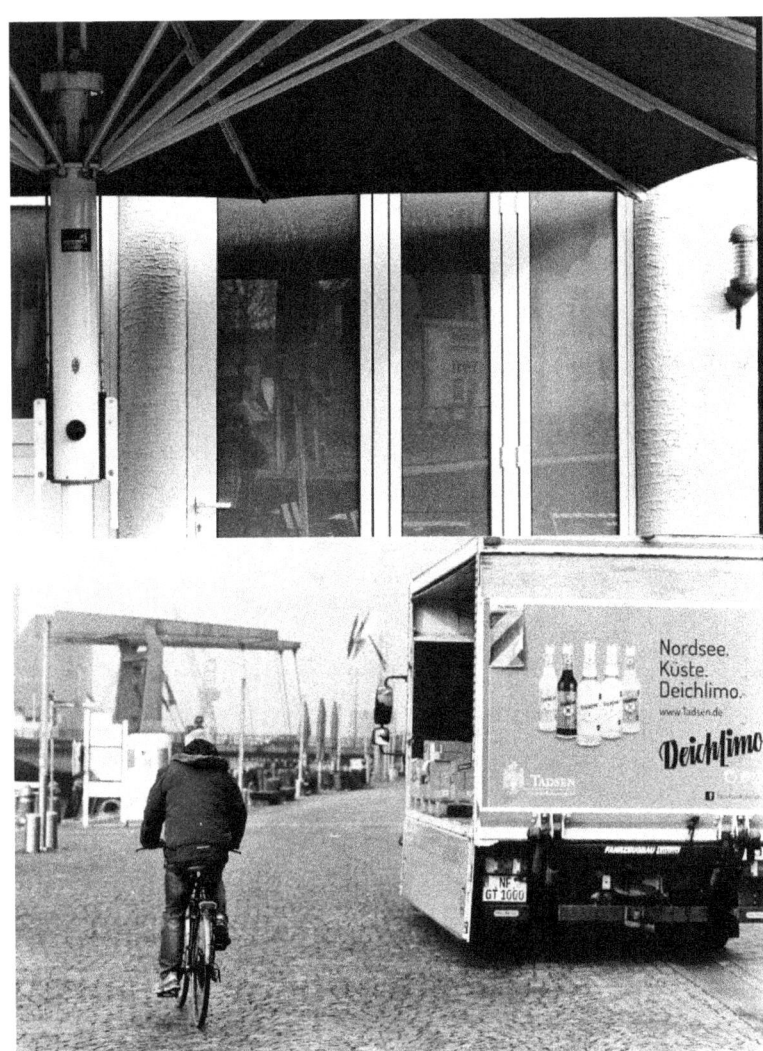

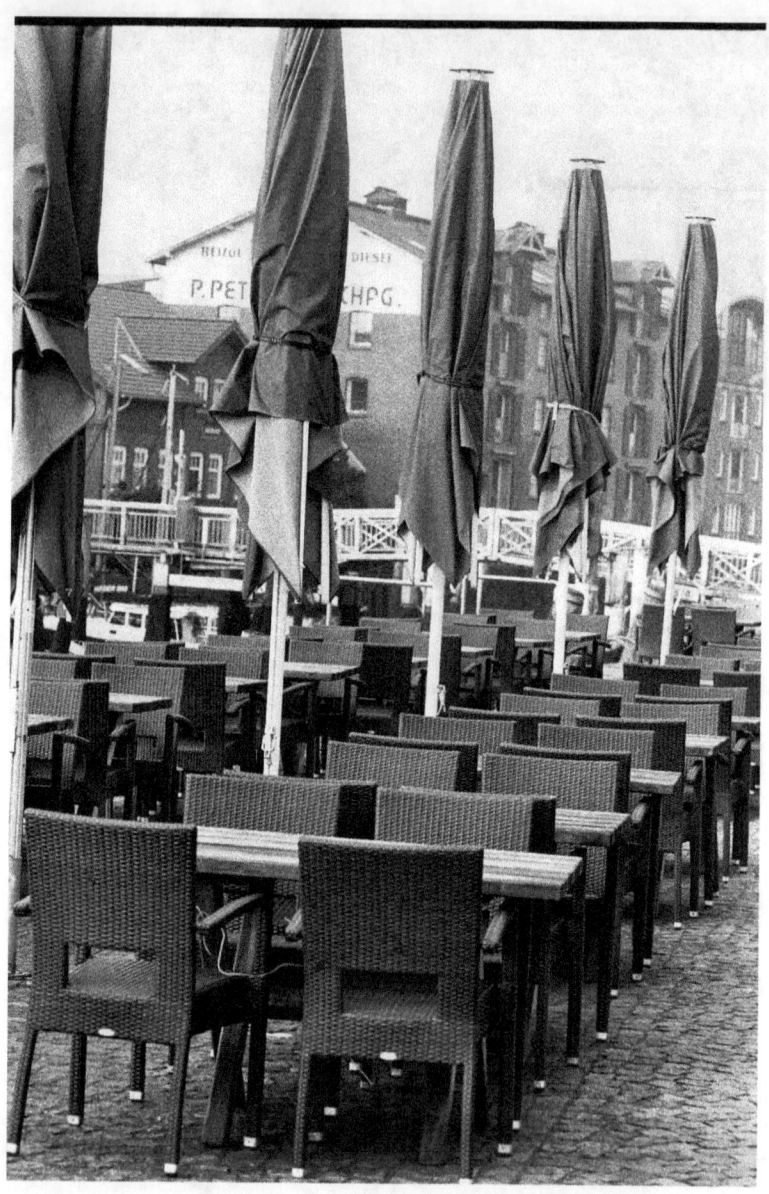

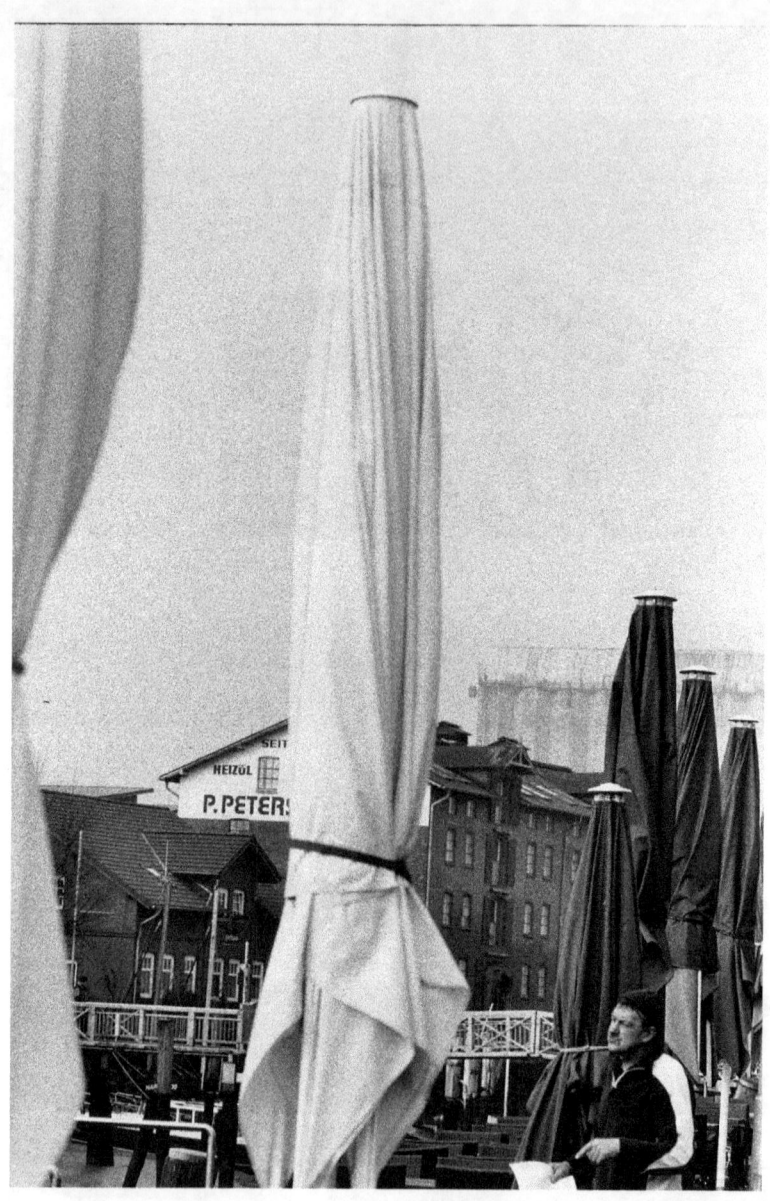

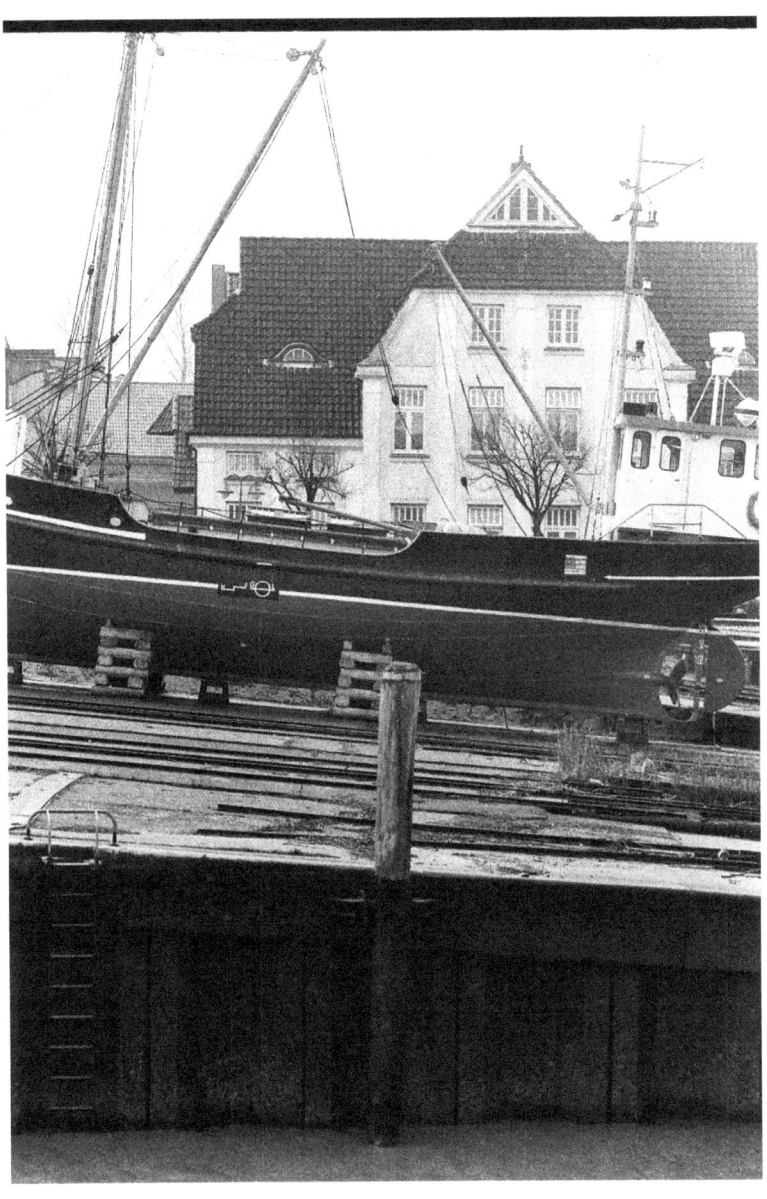

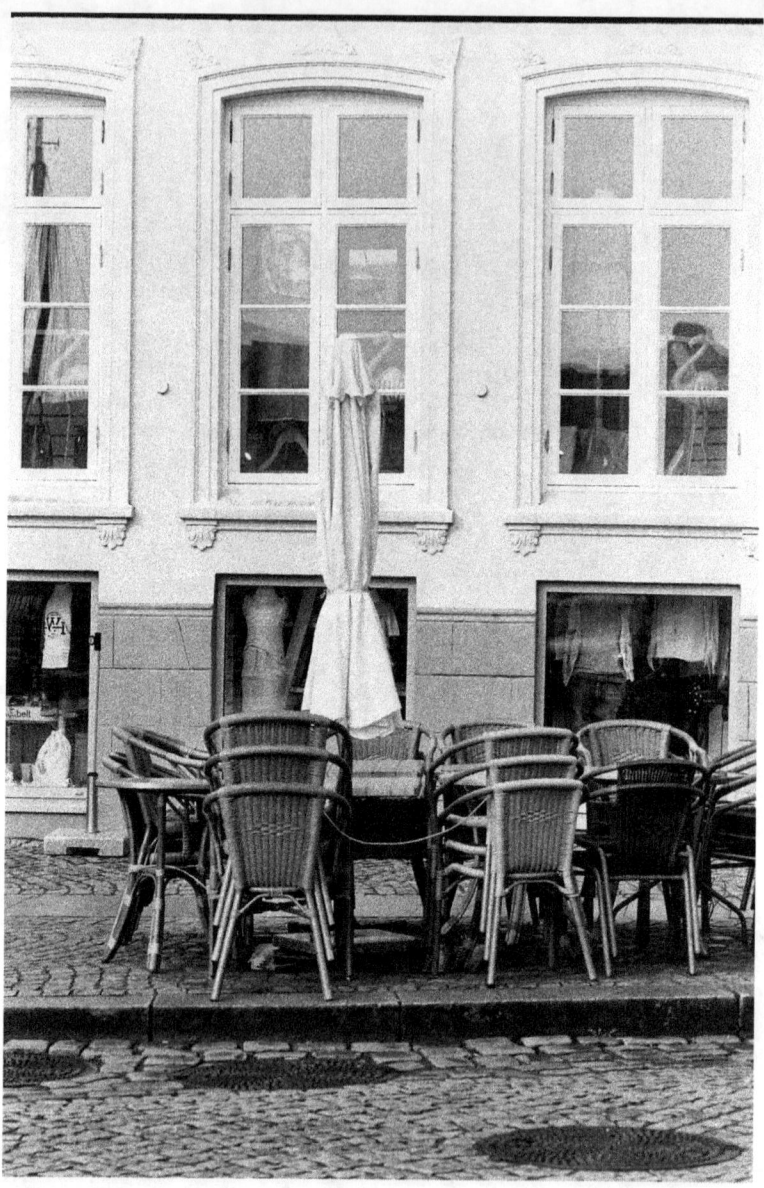

www.ingramcontent.com/pod-product-compliance
Lightning Source LLC
Chambersburg PA
CBHW051207170526
45158CB00005B/1852